D1689728

SPORTS GRAPHICS

P·I·E BOOKS

Copyright © 1994 by **P·I·E BOOKS**

All rights reserved. No part of this publication may be reproduced in any form or by any means, graphic, electronic or mechanical, including photocopying and recording by an information strage and retrieval system, without permission in writing from the publisher.

First published in Japan 1994 by:
P·I·E BOOKS
Villa Phoenix Suite 301, 4-14-6, Komagome, Toshima-ku,
Tokyo 170, Japan
TEL: 03-3949-5010 FAX: 03-3949-5650

ISBN4-938586-53-3 C3070 P16000E

First Published in Germany 1994 by:
NIPPAN / Nippon Shuppan Hanbai Deutschland GmbH
Krefelder Str. 85, D -40549 Düsserdolf (Heerdt), Germany
TEL: 0211-5048089 FAX: 0211-5049326

ISBN3-910052-40-1

Printed in Hong Kong by **Everbest Printing Co., Ltd.**

FOREWORD 4

Contents

TEAM SPORTS 9
Soccer
Basketball
Baseball
Ice Hockey
American Football

INDIVIDUAL SPORTS 83
Cycling
In-Line Skating
Track & Field
Fitness Training
Golf
Tennis

WATER SPORTS 127
Swimming
Surfing

SNOW SPORTS 153
Skiing
Snowboarding

SPORTS FASHION 205
Sports Fashion

SUBMITTORS' INDEX 217

はじめに

いつの世にも変わらず愛される、それが**スポーツ**である。参戦も観戦も（種目の流行りはあっても）すたり無く、日々人びとの間に浸透しているゆえんは、簡単に楽しめる割に得るものが大きい、ということからかもしれない。人間が身体をはって、ひとつの目標に向かい、跳ぶ、駆ける、舞い上がる。その**真摯な姿**は、時には奇蹟を呼び起こすこともある——こんなドラマティックな感動を体験したいがために、人々はスポーツを求めるのかもしれない。

その感動を陰ながら演出しているスポーツ・ウェアやグッズは、やはり真摯な**クリエイター**たちの手によって、日々研究の末に生み出されている。よりフィットし、より強さを発揮する商品をと、各社競争で素材の面から思案され、新製品のつどそこに着実に反映されている。数秒の内に、また数時間の限り、プレイヤーのひのき舞台を支えるその機能性には、時に目を見張るほど感心させられるものがある。

特に昨今のグッズで興味深いのは、その"機能性"を大前提にして、**デザイン性**がより重要視されている点である。むしろ機能美を全面にかかげる熱血的なイメージは過ぎ、デザイン的な要素でプレイヤーを引きつけ、実際に使用してみたら実によかった、という"**ファッション性**"がポイントになっている。同じ機能でもスタイルのバリエーションが増し、プレイヤーの趣味性でグッズを選ぶのが今やあたりまえの光景である——これは時代の風潮もあるのだろうが、それよりもスポーツの**メンタルな部分**に、クリエイターが目を向け出したからではないだろうか。言い過ぎでは

なく、スポーツグッズはプレイヤーにとっての**舞台衣装**である。ハデなプリントや美しいフォームは、プレイヤーに自信を持たせ、観客の興奮を増長させる。プレイヤーを活躍させるためには、機能性だけで満足するのでなく、**精神的な面**でのフォローも必要なことを、昨今のグッズは物語っているような気がする。

　ファッション界に負けず、シーズンごとに**モデル・チェンジ**を繰り返すアイテムたちは年々洗練されて登場する。ここでは1993年から1995年型のモデルが中心に紹介されているが、日本でのプロ・サッカー・リーグ"J.リーグ"開幕に、冬期オリンピック、サッカーのワールド・カップと、華々しいイベントがちょうど重なって行なわれた時期でもあり、特にデザインにその影響をかいま見ることができた。またこの３年間は、世情に暗いニュースが多かったが、スポーツの人気はあいかわらずで、止まるところを知らない。むしろそういう時代だからこそ、人々の**スポーツへの依存度**は高まっているのかもしれない。

　機能的にもデザイン的にも、スポーツ・グッズは今後どこまで発展し、つきつめられるのか——**皮膚の一部と化し**、風と一体化するその時まで、はてしなく真摯に開発は続いていくのだろう。ドラマを見続けていたいスポーツ・ファンとしても、期待は膨らんでいくばかりなのである。

<div style="text-align:right">ピエ・ブックス編集部</div>

Foreword

Regardless of the day and age, sport enjoys perennial popularity. The basic desire to compete, together with the urge to watch a match or competiton — these never seem to weaken, despite ups and downs in the appeal of individual sports. The only explanation for this can be that there is so much to be gained out of something so readily enjoyable. Athletes tense themselves to flout the challenge of their own particular targets. They sprint, they charge, they hurtle through the air. At times it seems their very determination itself can bring about miracles of achievement. And feeling this high-pitched excitement, being part of this drama, is what keeps people eternally fascinated by sport.

Sportswear and sporting equipment play a supporting role, but nevertheless an important one, in kindling sports fever. Products of ceaseless research, they are designed and manufactured by people equally fervent in their dedication. Sportswear that fits that much more smoothly and comfortably, equipement that can notch up a player's performance — the rivalry between competing manufacturers, working constantly on every aspect of their product from its basic material, is amply demonstrated each time new lines and models appear. We can only marvel at the fine-tuned functionality that carries the athlete through, perhaps in mere seconds, or else over hours of concentration, to his or her moment of glory.

Advances in the functional aspects of sporting equipment are these days taken for granted, but a welcome development in recent years is the growing emphasis placed on design. The days are over of the hot-blooded sports enthusiast seeking practicality to the exclusion of all else. Now it is often design factors which first catch the attention of players, who then try out these new products to find them just as satisfying in terms of their performance. We are seeing more and more variation in the styling of equipment or clothing produced for the same purpose, and players tend to make their selection according to their own personal taste. This may reflect a tendency of the times in which we live, but it also strongly suggests that those working to creat these products are looking more at the psychological aspects of playing sport. After all, the outfit with its accessories is the costume for the player's moment in the spotlight. The splashy prints and sleek lines add to the player's confidence as well as to the excitement of the crowd. These products are evidence that practicality is no longer enough to fire up the new generation of athletes. Sports goods must also embellish the bright, mordern spirit of sport.

New and more sophisticated line-ups of clothes and equipment appear with each new season, paralleling designers' collections in the fashion world. In this volume we are featuring designs for the years 1993 to 1995, a period that has happily coincided with several major events in the sports calender: the launch of Japan's professional soccer league, the J. League; the Winter Olympics at Lillehammer; and the soccer World Cup Finals in the US. The boost that these events have given is apparent in many of the designs. There has been no shortage of depressing news around the world over this period, but the popularity of sport is unabated — indeed, it may be that at times like these, people turn increasingly to sport to relieve the gloom on other fronts.

And what of the future? May we expect to see even more quality improvements in the performance and design of sports goods? No doubt, until the outfits fit like a second skin, until the athletes can match the speed of the wind, further development driven by the same earnest commitment will proceed without pause. And among sports fans eager for the drama to go on and on, the thrills and expectations will doubtless continue to grow.

P·I·E BOOKS

Der Sport erfreut sich ungebrochener Popularität – bei Jung und Alt, bei Mann und Frau, zu jeder Jahreszeit. Der grundsätzliche Wunsch sich im Wettbeweb zu messen, der Drang einem Spiel oder einem Wettkampf beizuwohnen, läßt offensichtlich nie nach, wenn auch die eine oder andere Sportart einmal im Zeitablauf an Attraktivität gewinnt beziehungsweise verliert. Die einzige Erklärung dafür ist, daß man viel gewinnen kann bei einem Sport und er so einfach verfügbar ist. Die Athleten setzen sich selbst unter Druck, um die Herausforderung ihrer eigenen persönlichen Ziele noch zu übertreffen. Sie sprinten, sie kämpfen, sie wirbeln durch die Luft. Manchmal erscheint es so, als ob ihre vollkommene Entschlossenheit selbst der Grund für ihre Bestleistungen sei. Diesen Ehrgeiz zu spüren, selbst diesem Kampf beizuwohnen und damit Mitspieler in diesem Drama zu sein – das ist es, was die Leute beim Sport jetzt und für immer fasziniert.

Die Sportbekleidung und -ausrüstung sind eine der wichtigsten Nebensachen beim Sport und doch sichtbarer Ausdruck des Sportfiebers. Die Marktforscher, Entwickler, Designer und Hersteller dieser Produkte erledigen ihre Aufgaben mit gleichem Eifer und gleicher Hingabe wie die Sportler. Die daraus resultierende Sportbekleidung sitzt dann noch besser und ist noch bequemer, die Ausrüstung ermöglicht noch bessere Ergebnisse. Die Rivalität zwischen den Herstellern, die fortwährend nicht nur am Material, sondern an jedem Aspekt ihrer Produkte arbeiten, wird immer dann deutlich, wenn neue Produktlinien oder neue Modelle vorgestellt werden. Wir können oft nur über die perfekte Abstimmung der Funktionalität der Produkte staunen, die die Athleten zum Moment des Sieges führt – sei es in nur wenigen Sekunden oder auch erst nach Stunden höchster Konzentration.

Heutzutage werden Fortschritte in den funktionalen Aspekten der Sportausrüstung oft für selbstverständlich genommen. Eine willkommene Entwicklung in den letzten Jahren ist die wachsende Betonung des Design. Die Tage, in denen der heißspornige Sportenthusiast pure Praktikalität verlangte, sind vorbei. Heute sind es oft Design-Faktoren, die zuerst die Aufmerksamkeit der Sportler auf sich ziehen. Nachdem sie die Produkte dann ausprobiert haben, sind sie gleichermaßen begeistert von der Funktionalität. Wir sehen heute immer mehr Variationen im Styling der Ausrüstung und in der Kleidung für einen bestimmten Sport. Die Sportler tendieren jetzt dazu, nach ihrem persönlichen Geschmack auszuwählen. Dies mag ein genereller Trend in der heutigen Zeit sein, aber man muß wohl auch annehmen, daß die Leute, die diese Produkte kreieren, stärker auf die psychologischen Aspekte der sportlichen Betätigung achten. Bei alledem ist die Ausrüstung mit seinem Zubehör das Kostüm für den Moment, in dem der Spieler im Scheinwerferlicht steht. Die spritzigen Motive und die ansprechenden Linien unterstützen das Selbstvertrauen des Sportlers und die Begeisterung der Zuschauermassen. Diese Produkte sind der Beweis dafür, daß die Praktikabilität allein heute nicht mehr genügt, um die neue Sportlergeneration anzufeuern. Sport-Produkte müssen auch verschönern und ausschmücken und so den heiteren, modernen Sportsgeist widerspiegeln.

Neue und noch raffiniertere Sortimente von Sportkleidern und -ausrüstungsgegenständen erscheinen zu jeder neuen Saison, parallel zu den Designer-Kollektionen in der Modewelt. In diesem Buch zeigen wir Designs der Jahre 1993 bis 1995, einen Zeitabschnitt, in den glücklicherweise einige besonders wichtige Sportereignisse fielen: die Winterolympiade in Lillehammer, die Fußballweltmeisterschaft in den USA, der Start der "J. League", der Fußball-Profi-Liga in Japan u.a. Der Aufwind durch diese Ereignisse spiegelt sich in vielen der Designs wider. Während dieser Zeit gab es in der Welt keinen Mangel an schlechten Nachrichten, aber die Popularität des Sports ist unbestritten. Vielleicht ist es sogar so, daß die Leute sich in Zeiten wie diesen intensiver dem Sport zuwenden, um der Hoffnungslosigkeit an anderen Fronten zu entgehen.

Und wie sieht die Zukunft aus? Können wir noch weitere Verbesserungen in der Qualität und dem Design der Sportprodukte erwarten? Kein Zweifel; solange die Kleidung nicht wie eine zweite Haut sitzt, solange der Athlet nicht vollkommen windschlüpfrig ist, solange wird es Weiterentwicklungen geben – betrieben mit der gleichen Ersthaftigkeit und mit dem gleichen Nachdruck. Und unter den Sportfans, glerig nach noch mehr Dramatik, wird ohne Zweifel die Erwartung und die Spannung weiter steigen.

P·I·E BOOKS

Editorial Notes

Credit Format
a.(reference letter) brand name-product or team name
/ type of product handling company

Handling companies are classified as follows:
 M: =Manufacturer
 LM: =Licensed Manufacturer
 I: =Importer
Companies listed as licensed manufacturers or importers are companies responsible for handling the product in Japan. The words "Company Limited" and "Incorporated" have been omitted from the credits in this book.

a.(照合No.) ブランド名−製品名orチーム名
/ 製品形態 製品取扱会社名or取扱店名

クレジット中、製品取扱会社名（取扱店名）は
以下の通りに分類し、記載しました。
 M: =Manufacturer
 LM: =Licensed Manufacturer
 I: =Importer
Licensed Manufacturer、Importerについては、
日本での製品の取扱会社（取扱店）名を記載しました。
会社名については株式会社、
Company Limited, Incorporated等の表記を省略しました。

Soccer 10

Basketball 36

TEAM SPORTS

Baseball 62

Ice Hockey 72

American Football 78

Soccer

10

a., b. Kick-World Soccer USA '94 / T-shirts I: World Sports Plaza Campione

11

TEAM SPORTS

Soccer

12

a., b. Asics-Aston Villa / Team Shirts I: World Sports Plaza Campione **c. Umbro-Ajax** / Team Shirts I: World Sports Plaza Campione
d. Asics-New Castle United / Team Shirts I: World Sports Plaza Campione **e. Penalty-Gremio** / Team Shirts I: World Sports Plaza Campione
f. Lotto-A·C·Miran / Team Shirts I: World Sports Plaza Campione **g. Ribero-Crystal Palace** / Team Shirts I: World Sports Plaza Campione
h. Asics-Hearts / Team Shirts I: World Sports Plaza Campione

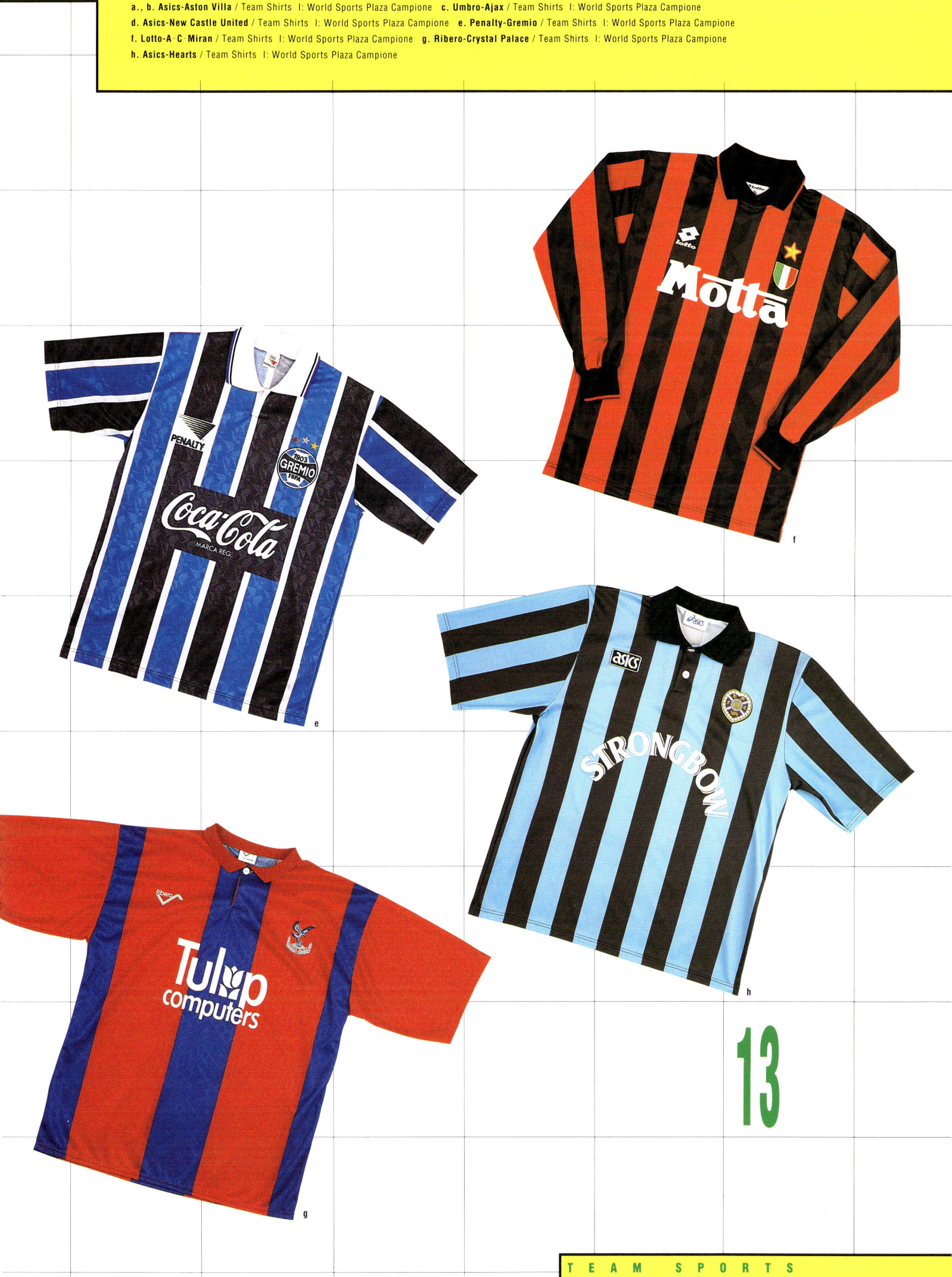

13

TEAM SPORTS

Soccer

14

a. **Umbro-Internazionale Mirano** / Team Shirts l: World Sports Plaza Campione b. **Kappa-Kaizer Chiefs** / Team Shirts l: World Sports Plaza Campione
c. **Duarig-Lyonnais** / Team Shirts l: World Sports Plaza Campione d. **adidas-Ghana National Team** / Team Shirts l: World Sports Plaza Campione
e. **Umbro-Tottenham Hotspur** / Team Shirts l: World Sports Plaza Campione f. **adidas-F.C. Shalke 04** / Team Shirts l: World Sports Plaza Campione

15

TEAM SPORTS

Soccer

16

a. **Asics-Portsmouth** / Team Shirts I: World Sports Plaza Campione b. **Admiral-Leeds United** / Team Shirts I: World Sports Plaza Campione
c. **CCS-Ituano** / Team Shirts I: World Sports Plaza Campione d. **Dellerba-C.A. Bragantino** / Team Shirts I: World Sports Plaza Campione
e. **Kappa-South Africa National Team** / Team Shirts I: World Sports Plaza Campione f. **Puma-Frankfurt Eintracht** / Team Shirts I: World Sports Plaza Campione
g. **Nike-Pari S.G.** / Team Shirts I: World Sports Plaza Campione h. **Puma-SV Werder Bremen** / Team Shirts I: World Sports Plaza Campione

17

TEAM SPORTS

Soccer

18

a. **Pienne-Pescara Calcio** / Team Shirts I: World Sports Plaza Campione b. **Lotto-A C Fiorentina** / Team Shirts I: World Sports Plaza Campione
c. **Gems-F C La Chaux-de Fonds** / Team Shirts I: World Sports Plaza Campione d. **Duarig-Toulouse F C** / Team Shirts I: World Sports Plaza Campione
e. **Lotto-Den Haag** / Team Shirts I: World Sports Plaza Campione f. **Umbro-Parma A.C.** / Team Shirts I: World Sports Plaza Campione
g. **Umbro-Manchester United** / Team Shirts I: World Sports Plaza Campione h. **Asics-Sampdoria** / Team Shirts I: World Sports Plaza Campione

TEAM SPORTS

Soccer

20

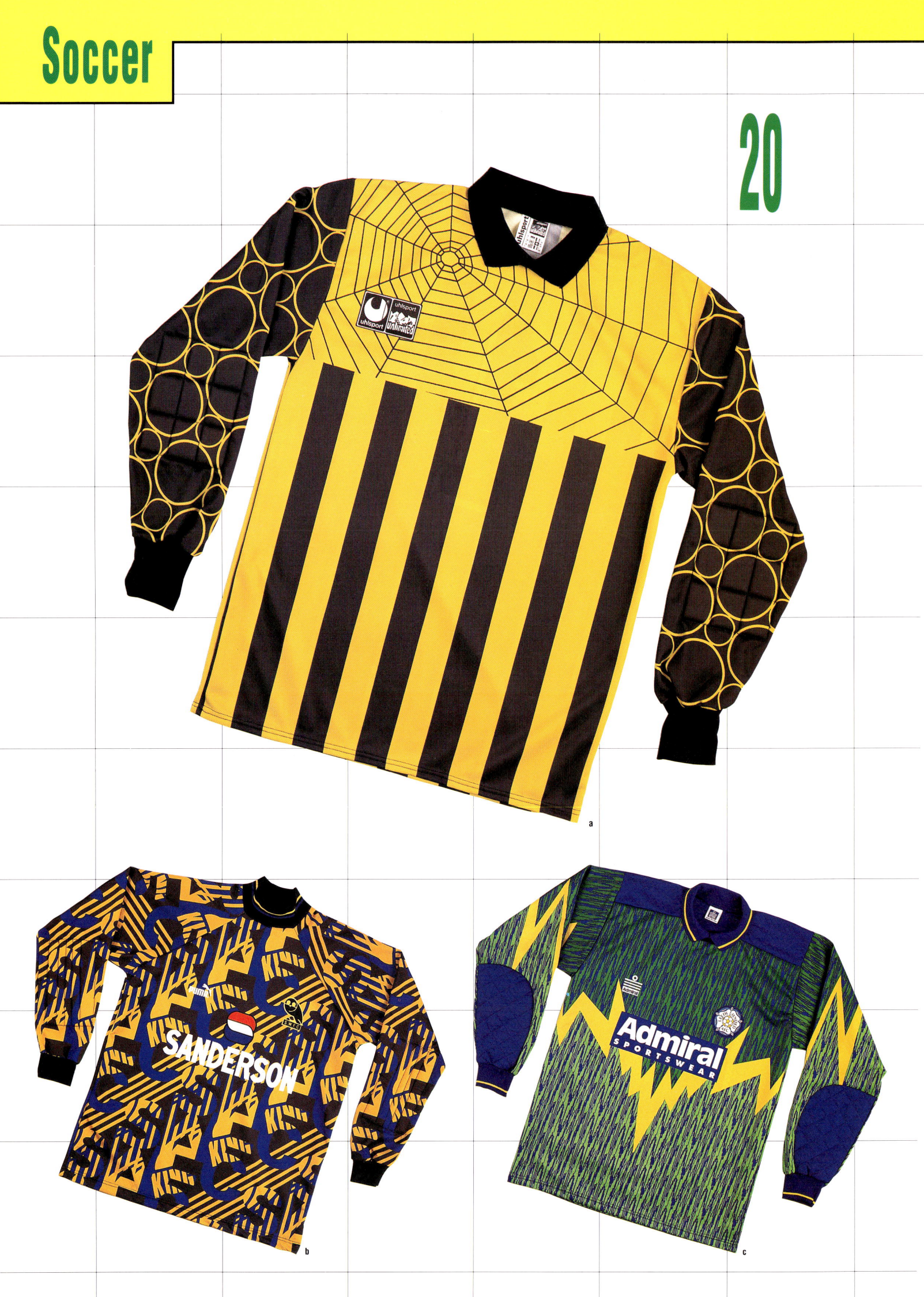

a. **Uhlsport-Genoa** / Goalkeeper's Shirts I: World Sports Plaza Campione b. **Puma-Sheffield Wednesday** / Goalkeeper's Shirts I: World Sports Plaza Campione
c. **Admiral-Leeds United** / Goalkeeper's Shirts I: World Sports Plaza Campione d. **Puma Soccer** / Goalkeeper's Shirts LM: Hit Union
e. **Uhlsport-Minerven** / Goalkeeper's Shirts I: World Sports Plaza Campione f. **Umbro-Parma A.C.** / Goalkeeper's Shirts I: World Sports Plaza Campione

21

TEAM SPORTS

Soccer

22

a.-e. Asics-Japan National Team / a., b., d. Team Uniforms, c., e. Goalkeeper's Uniforms M: Asics

23

TEAM SPORTS

Soccer

24

a., b. J. League-Shimizu S-Pulse / Team Shirts M: Mizuno c., d. J. League-Urawa Red Diamonds / Team Shirts M: Mizuno
e., f. J. League-Bellmare Hiratsuka / Team Shirts M: Mizuno

TEAM SPORTS

Soccer

26

a., b. J. League-Sanfrecce Hiroshima / Team Shirts M: Mizuno c., d. J. League-A·S Flügels / Team Shirts M: Mizuno e., f. J. League-Gamba Osaka / Team Shirts M: Mizuno
g., h. J. League-Nagoya Grampus Eight / Team Shirts M: Mizuno i., j. J. League-Jef United / Team Shirts M: Mizuno

TEAM SPORTS

Soccer

28

a. **J. League-Yomiuri Verdy** / Team Shirts M: Mizuno b. **J. League-Yokohama Marinos** / Team Shirts M: Mizuno c., d. **J. League-Júbilo Iwata** / Team Shirts M: Mizuno
e., f. **J. League-Kashima Antlers** / Team Shirts M: Mizuno

29

TEAM SPORTS

Soccer

a.-c. Puma / Goalkeeper's Gloves I: Cosa Liebermann **d., e. Puma** / Shin Guards I: Cosa Liebermann **f. adidas-adi Safe Pro** / Shin Guards LM: Descente
g., h. adidas / Shin Guards LM: Descente **i. adidas-adi Grip Wet** / Goalkeeper's Gloves LM: Descente **j. adidas-adi Grip Equipment** / Goalkeeper's Gloves LM: Descente

31

TEAM SPORTS

Soccer

32

a. **adidas-Mexico Goal** / Training Boots LM: Descente b. **adidas-Ortona** / Training Boots LM: Descente c. **Puma-Comodoro** / Match Boots I: Cosa Liebermann
d. **adidas-Penarol Team** / Training Boots LM: Descente e. **adidas-Mexico Team** / Training Boots LM: Descente f. **Puma-Magnate Top** / Match Boots I: Cosa Liebermann
g. **Puma-Mid-fielder Allround** / Training Boots I: Cosa Liebermann h. **Puma-Escalera** / Match Boots I: Cosa Liebermann i. **adidas-Alfaro** / Match Boots LM: Descente
j. **adidas-Madura** / Match Boots LM: Descente

33

TEAM SPORTS

Soccer

34

a. **adidas-Print** Ⅲ / Bags LM: Descente b. **adidas-Shadow** Ⅲ / Bags LM: Descente c., d. **adidas-Stadium** Ⅰ, **Soccer Junior** Ⅱ / Bags LM: Descente
e. **Puma** / Bags I: Cosa Liebermann

35

TEAM SPORTS

Basketball

36

a. Champion-Miami Heat / Team Uniforms l: World Sports Plaza 2 **b. Champion-Orlando Magic** / Team Uniforms l: World Sports Plaza 2
c. Champion-Utah Jazz / Team Uniforms l: World Sports Plaza 2 **d. Champion-Portland Trail Blazers** / Team Uniforms l: World Sports Plaza 2

37

TEAM SPORTS

Basketball

a. **Champion-Philadelphia Sixers** / Team Jerseys I: World Sports Plaza 2 b. **Champion-Phoenix Suns** / Team Jerseys I: World Sports Plaza 2
c. **Champion-New York Knicks** / Team Jerseys I: World Sports Plaza 2 d. **Salem-Chicago Bulls** / T-shirts I: World Sports Plaza 2
e. **Reebok-Shaq** / T-shirts I: World Sports Plaza 2 f. **Salem-Boston Celtics** / T-shirts I: World Sports Plaza 2 g. **The Game-Phoenix Suns** / T-shirts I: World Sports Plaza 2

39

TEAM SPORTS

Basketball

a

b

c

d

40

a. **Changes-Los Angeles Lakers** / T-shirts l: World Sports Plaza 2 b. **Super Shirts-Miami Heat** / T-shirts l: World Sports Plaza 2
c. **Salem-Portland Trail Blazers** / T-shirts l: World Sports Plaza 2 d. **Salem-Los Angeles Lakers** / T-shirts l: World Sports Plaza 2
e. **Salem-Detroit Pistons** / T-shirts l: World Sports Plaza 2 f. **Salem-Philadelphia Sixers** / T-shirts l: World Sports Plaza 2
g. **Nike** / T-shirts l: World Sports Plaza 2 h. **Starter-Portland Trail Blazers** / T-shirts l: World Sports Plaza 2

41

a. **Changes-Los Angeles Lakers** / T-shirts l: World Sports Plaza 2 b. **Super Shirts-Miami Heat** / T-shirts l: World Sports Plaza 2
c. **Salem-Portland Trail Blazers** / T-shirts l: World Sports Plaza 2 d. **Salem-Los Angeles Lakers** / T-shirts l: World Sports Plaza 2
e. **Salem-Detroit Pistons** / T-shirts l: World Sports Plaza 2 f. **Salem-Philadelphia Sixers** / T-shirts l: World Sports Plaza 2
g. **Nike** / T-shirts l: World Sports Plaza 2 h. **Starter-Portland Trail Blazers** / T-shirts l: World Sports Plaza 2

TEAM SPORTS

Basketball

a.-c., f. **Wilson** / T-shirts LM: Hit Union d. **M'otto RedDot-Woofin** / T-shirts M: M'otto e. **M'otto RedDot-Dish it Out** / T-shirts M: M'otto

43

TEAM SPORTS

Basketball

a back

44

a

b

a.-e. Nike / T-shirts M: Nike Japan

45

TEAM SPORTS

Basketball

46

a., d. Nutmeg-New York Knicks / T-shirts l: World Sports Plaza 2 **b., e., g., h. Salem-Chicago Bulls** / T-shirts l: World Sports Plaza 2
c. Magic Johnson-Orland Magic / T-shirts l: World Sports Plaza 2 **f. Salem-Los Angeles Lakers** / T-shirts l: World Sports Plaza 2

47

TEAM SPORTS

Basketball

48

a. **Nike-Charles Barkley** / T-shirts I: World Sports Plaza 2 b. **Nike** / T-shirts I: World Sports Plaza 2 **c., d. Reebok** / T-shirts M: Reebok Japan
e. **Logo 7-Orland Magic** / T-shirts I: World Sports Plaza 2 f. **adidas-Mutombo** / T-shirts I: World Sports Plaza 2

49

TEAM SPORTS

Basketball

50

a. Nike-Charles Barkley / T-shirts I: World Sports Plaza 2 **b.** Salem-Michael Jordan / T-shirts I: World Sports Plaza 2 **c.** Nike-Michael Jordan / T-shirts I: World Sports Plaza 2
d. Salem-Charles Barkley / T-shirts I: World Sports Plaza 2 **e.** Salem-Harry Johnson / T-shirts I: World Sports Plaza 2 **f.** Reebok-Shaq / T-shirts I: World Sports Plaza 2

51

f back

Basketball

52

a
b
c
d
f
g

a., c.-f., i.-k., m. Spalding-NBA / Balls LM: Tachikara b. Spalding-Houstan Rockets / Balls LM: Tachikara g. Spalding-Los Angeles Lakers / Balls LM: Tachikara
h. Spalding-San Antonio Spurs / Balls LM: Tachikara l. Spalding-Chicago Bulls / Balls LM: Tachikara n. Spalding-Denver Nuggets / Balls LM: Tachikara

53

TEAM SPORTS

Basketball

54

a. Reebok-Spector Mid / Shoes M: Reebok Japan **b. Reebok-Central Park** / Shoes M: Reebok Japan **c. Reebok-Shaq II Mid** / Shoes M: Reebok Japan
d. Reebok-D Factor Low / Shoes M: Reebok Japan **e. Asics-Gelsky** / Shoes M: Asics

55

TEAM SPORTS

Basketball

56

a
b
c
d
e

a., c. adidas-Streetball III Mid / Shoes LM: Descente **b. adidas-Equipment Basketball Boots** / Shoes LM: Descente **d. adidas-Response Sock Mid** / Shoes LM: Descente
e. adidas-Mutombo II Mid / Shoes LM: Descente **f. Puma-Disc System Hocus Nubuck** / Shoes I: Cosa Liebermann
g. Puma-Disc System Hocus / Shoes I: Cosa Liebermann **h. Asics-GT Drive MT-2** / Shoes M: Asics **i. Fila** / Shoes LM: Kanebo. Fila Division

57

TEAM SPORTS

Basketball

58

a. **Nike-Sky Jordan (for kids')** / Shoes M: Nike Japan b. **Nike-Air Unlimited** / Shoes M: Nike Japan c. **Nike-Air Force Max CB** / Shoes M: Nike Japan
d. **Nike-Air Check** / Shoes M: Nike Japan e. **Nike-Air Maestro Hi** / Shoes M: Nike Japan f.-i. **adidas-Bronx II** / Bags LM: Descente

TEAM SPORTS

Basketball

60

a., n. **Atlanta Hawks** / Caps l: World Sports Plaza 2 b. **Boston Celtics** / Caps l: World Sports Plaza 2 c. **New York Knicks** / Caps l: World Sports Plaza 2
d. **Chicago Bulls** / Caps l: World Sports Plaza 2 e., h. **Shaq** / Caps l: World Sports Plaza 2 f. **Portland Trail Blazers** / Caps l: World Sports Plaza 2
g. **Charlotte Hornets** / Caps l: World Sports Plaza 2 i. **Orland Magic** / Caps l: World Sports Plaza 2 j. **New York Knicks** / Caps l: World Sports Plaza 2
k. **Houston Rockets** / Caps l: World Sports Plaza 2 l. **Los Angeles Lakers** / Caps l: World Sports Plaza 2 m. **Golden State Warriors** / Caps l: World Sports Plaza 2

61

TEAM SPORTS

Baseball

62

a. **Russell-Oakland Athletics** / Team Jerseys I: MLB Japan Shop b. **Logo 7-New York Yankees** / Training Jerseys I: MLB Japan Shop
c. **Russell-Montreal Expos** / Team Jerseys I: MLB Japan Shop d. **Rawlings-New York Mets** / Team Jerseys I: MLB Japan Shop
e. **Russell-Chicago Cubs** / Team Jerseys I: MLB Japan Shop f. **Russell-Atlanta Braves** / Team Jerseys I: MLB Japan Shop
g. **Russell-Houston Astros** / Team Jerseys I: MLB Japan Shop h. **Russell-Toront Blue Jays** / Team Jerseys I: MLB Japan Shop

TEAM SPORTS

Baseball

a

b

c

64

d

a. **Majestic-St. Louis Cardinals** / Training Jerseys I: MLB Japan Shop b. **Russell-Kansas City Royals** / Team Jerseys I: MLB Japan Shop
c. **Russell-San Diego Padres** / Team Jerseys I: MLB Japan Shop d. **Majestic-Colorado Rockies** / Training Jerseys I: MLB Japan Shop
e. **Majestic-New York Mets** / Training Jerseys I: MLB Japan Shop f. **Russell-Florida Marlins** / Team Jerseys I: MLB Japan Shop
g. **Russell-Philadelphia Phillies** / Team Jerseys I: MLB Japan Shop h. **Majestic-Florida Marlins** / Training Jerseys I: MLB Japan Shop

65

TEAM SPORTS

Baseball

66

a. Starter-Chicago White Sox / T-shirts l: MLB Japan Shop **b.** Starter-Florida Marlins / T-shirts l: MLB Japan Shop **c.** Logo 7-Los Angeles Dodgers / T-shirts l: MLB Japan Shop
d. Starter-New York Yankees / T-shirts l: MLB Japan Shop **e.** Starter-Oakland Athletics / T-shirts l: MLB Japan Shop **f.** Starter-New York Mets / T-shirts l: MLB Japan Shop
g. Salem-Boston Red Sox / T-shirts l: MLB Japan Shop **h.** Nike-Pittsburgh Pirates / T-shirts l: MLB Japan Shop
i. College Concepts-Colorado Rockies / T-shirts l: MLB Japan Shop **j.** College Concepts-Philadelphia Phillies / T-shirts l: MLB Japan Shop

67

TEAM SPORTS

Baseball

SURE
BABE RUTH
WAS GOOD
BUT COULD HE
PLAY HOOP?

THE
GREAT
AMERICAN
PASTIME
JUST GOT
GREATER

MICHAEL JORDAN
NIKE

back

a

b

68

RED ERASER

Bumbershoot

c

a. Nike-Michael Jordan / T-shirts I: MLB Japan Shop **b. M'otto RedDot** / T-Shirts M: M'otto **c. Bumbershoot** / Training Jersey M: One Reel
d. Starter-Cincinnati Reds / Jackets I: MLB Japan Shop **e. Starter-Montreal Expos** / Jackets I: MLB Japan Shop **f., g. Starter-Oakland Athletics** / Jackets I: MLB Japan Shop

69

TEAM SPORTS

Baseball

70

a. **Chicago White Sox** / Caps I: MLB Japan Shop b. **California Angels** / Caps I: MLB Japan Shop c. **MLB Cooperstown Collection** / Caps I: MLB Japan Shop
d. **Cleveland Indians** / Caps I: MLB Japan Shop e. **Techfire SF** / Gloves M: Mizuno f. **Florida Marlins** / Caps I: MLB Japan Shop
g., h. **Baltimore Orioles** / Caps I: MLB Japan Shop i. **Minnesota Twins** / Caps I: MLB Japan Shop j. **Toronto Blue Jays** / Caps I: MLB Japan Shop
k. **Oakland Athletics** / Caps I: MLB Japan Shop l. **Montreal Expos** / Caps I: MLB Japan Shop m. **Philadelphia Phillies** / Caps I: MLB Japan Shop
n. **Cincinnati Reds** / Caps I: MLB Japan Shop o. **Texas Rangers** / Caps I: MLB Japan Shop

71

TEAM SPORTS

Ice Hockey

72

a. **CCM-New Jersey Devils** / Team Jerseys I: World Sports Plaza b. **CCM-Chicago Black Hawks** / Team Jerseys I: World Sports Plaza
c. **CCM-Ottawa Senators** / Team Jerseys I: World Sports Plaza d. **CCM-Philadelphia Flyers** / Team Jerseys I: World Sports Plaza
e. **CCM-Anaheim Mighty Ducks** / Team Jerseys I: World Sports Plaza f. **CCM-San Jose Sharks** / Team Jerseys I: World Sport Plaza
g. **CCM-Florida Panthers** / Team Jerseys I: World Sports Plaza h. **CCM-Edmonton Oilers** / Team Jerseys I: World Sports Plaza

73

TEAM SPORTS

Ice Hockey

74

a. CCM-Pittsburgh Penguins / Team Jerseys I: World Sports Plaza **b. CCM-Detroit Red Wings** / Team Jerseys I: World Sports Plaza
c. CCM-Vancouver Canucks / Team Jerseys I: World Sports Plaza **d. CCM-Boston Bruins** / Team Jerseys I: World Sports Plaza
e. CCM-Buffalo Sabres / Team Jerseys I: World Sports Plaza

75

TEAM SPORTS

Ice Hockey

76

a. **Logo 7-Detroit Red Wings** / Training Jerseys l: World Sports Plaza b. **Champion-New Jersey Devils** / T-shirts l: World Sports Plaza
c. **Logo 7-Montreal Canadiens** / Training Jerseys l: World Sports Plaza d. **Salem-Florida Panthers** / T-shirts l: World Sports Plaza
e. **Logo 7-New York Islanders** / T-shirts l: World Sports Plaza f. **Salem-Los Angeles Kings** / T-shirts l: World Sports Plaza
g. **Starter-Philadelphia Flyers** / T-shirts l: World Sports Plaza h. **Logo 7-Chicago Black Hawks** / T-shirts l: World Sports Plaza
i. **Logo 7-Boston Bruins** / T-shirts l: World Sports Plaza

77

TEAM SPORTS

American Football

78

a. **Riddell-Atlanta Falcons** / Helmets I: World Sports Plaza b. **Wilson-Los Angeles Raiders** / Training Jerseys I: World Sports Plaza
c. **Champion-San Francisco 49ers** / Team Jerseys I: World Sports Plaza d. **Riddell-Los Angeles Raiders** / Helmets I: World Sports Plaza
e. **Russell-Los Angeles Rams** / Team Jerseys I: World Sports Plaza f. **Champions-Denver Broncos** / Team Jerseys I: World Sports Plaza
g. **Riddell-Dallas Cowboys** / Helmets I: World Sports Plaza h. **Russell-Dallas Cowboys** / Team Jerseys I: World Sports Plaza
i. **Riddell-Philadelphia Eagles** / Helmets I: World Sports Plaza j. **Russell-Philadelphia Eagles** / Team Jerseys I: World Sports Plaza

E A M S P O R T S

American Football

80

a. **Salem-Boomer Esiason** / T-shirts I: World Sports Plaza b. **Salem-Dan Marino** / T-shirts I: World Sports Plaza
c., h. **Salem-San Francisco 49ers** / c. T-shirts, h. Shirts I: World Sports Plaza d. **Nike-NCAA** / T-shirts I: World Sports Plaza
e. **Logo 7-New York Giants** / T-shirts I: World Sports Plaza f. **Changes-Washington Red Skins** / Shirts I: World Sports Plaza
g. **Starter-Dallas Cowboys** / T-shirts I: World Sports Plaza i. **Salem-Atlanta Falcons** / T-shirts I: World Sports Plaza
j. **Salem-Dallas Cowboys** / T-shirts I: World Sports Plaza

81

TEAM SPORTS

American Football

a., c. **Starter-Dallas Cowboys** / T-shirts l: World Sports Plaza b. **Salem-Miami Dolphins** / T-shirts l: World Sports Plaza d. **Salem-Los Angeles Raiders** / Shirts l: World Sports Plaza

82

Cycling 84

In-Line Skating 92

Track & Field 94

INDIVIDUAL SPORTS

Fitness Training 102

Golf 106

Tennis 110

Cycling

84

a. **Pearl Izumi-Power Bar** / Jerseys and Tights M: Pearl Izumi b. **Pearl Izumi-Fujitsu** / Jerseys and Tights M: Pearl Izumi
c. **Pearl Izumi-John Tomac** / Jerseys and Tights M: Pearl Izumi d. **Pearl Izumi** / Jerseys and Tights M: Pearl Izumi

85

INDIVIDUAL SPORTS

Cycling

a

b

c

86

d

a. Pearl Izumi-Coors Light / Jerseys M: Pearl Izumi **b.** Pearl Izumi-Shakariki / Jerseys M: Pearl Izumi **c.** Pearl Izumi-John Tomac / Jerseys M: Pearl Izumi
d. Pearl Izumi-Carpenter/Phinney / Jerseys M: Pearl Izumi **e.** Pearl Izumi-Save the Trails / Jerseys M: Pearl Izumi **f.** Pearl Izumi / Jerseys M: Pearl Izumi
g. Pearl Izumi-Pearl World / Jerseys M: Pearl Izumi **h.** Pearl Izumi-Cannondale / Jerseys M: Pearl Izumi

87

INDIVIDUAL SPORTS

Cycling

a

b

c

a., c., f. **Raleigh** / Bikes M: Raleigh Cycle Company of America b., e., g. **Giro** / Helmets M: Giro Sport Design d. **Aussie-Specialized** / Jerseys and Tights I: Daiwa Seiko

Cycling

90

a

b

c

d

e

f

a. Pearl Izumi-Cannondale / Gloves M: Pearl Izumi **b., d.** Pearl Izumi-Stained Dream / Gloves M: Pearl Izumi **c.** Pearl Izumi-Inoac Deki / Jerseys M: Pearl Izumi
e., f. Pearl Izumi-Psycho Spark / Gloves M: Pearl Izumi **g.** Pearl Izumi-Power Bar / Gloves M: Pearl Izumi **h.** Pearl Izumi-USCF / Gloves M: Pearl Izumi
i. Pearl Izumi / Gloves M: Pearl Izumi **j.** Pearl Izumi-Dilettante / Jerseys M: Pearl Izumi **k.** Pearl Izumi-John Tomac / Gloves M: Pearl Izumi
l. Pearl Izumi-Coors Light / Gloves M: Pearl Izumi

91

INDIVIDUAL SPORTS

In-Line Skating

92

a. **Rollerblade-Metroblade** / Skates M: Nordica Japan b. **Rollerblade-Racerblade** / Skates M: Nordica Japan c. **Rollerblade-Macroblade Equipe** / Skates M: Nordica Japan
d. **Rollerblade-Macroblade Equipe Lady** / Skates M: Nordica Japan e. **Rollerblade-Slalomblade** / Skates M: Nordica Japan f. **Rollerblade-Problade** / Skates M: Nordica Japan

93

INDIVIDUAL SPORTS

Track & Field

94

a.-d. adidas / Running Shirts and Pants LM: Descente **e., f. Mizuno R1** / Running Shirts and Pants M: Mizuno **g., h. Puma Racing** / Running Shirts and Pants LM: Hit Union

95

INDIVIDUAL SPORTS

Track & Field

96

a. Reebok-Ventilator / Running Shoes M: Reebok Japan **b. Reebok-Pump Graphlite** / Running Shoes M: Reebok Japan **c. Reebok-Pump Fury** / Running Shoes M: Reebok Japan
d. Nike-Air Huarache Light / Running Shoes I: Nike Japan **e. Nike-Air Structure II** / Running Shoes I: Nike Japan **f. Nike-Air Tailwind** / Running Shoes I: Nike Japan
g. Nike-Lady Air Max / Running Shoes I: Nike Japan **h. Nike-Lady Air Huarache Light** / Running Shoes I: Nike Japan

97

INDIVIDUAL SPORTS

Track & Field

98

a. Asics-Tiger Bow XX-9 / Sprinting Shoes M: Asics **b. Asics-Tarther CX-α** / Running Shoes M: Asics **c. Asics-Tarther SV-α** / Running Shoes M: Asics
d. Mizuno-Super Athlete LX / Sprinting Shoes M: Mizuno

99

INDIVIDUAL SPORTS

Track & Field

a

b

c

a. **Puma-Disc System Turbine** / Running Shoes I: Cosa Liebermann b. **Puma-Disc System Braze** / Running Shoes I: Cosa Liebermann
c. **Puma-Disc System Trial** / Running Shoes I: Cosa Liebermann d. **adidas-Tubular 2** / Running Shoes LM: Descente
e. **adidas-Torsion Libenge S** / Running Shoes LM: Descente f. **adidas classic** / Running Shoes LM: Descente g. **adidas-Torsion Response Light** / Running Shoes LM: Descente
h. **adidas-Torsion Banes EX** / Running Shoes LM: Descente i. **adidas-Tech Performance** / Running Shoes LM: Descente

INDIVIDUAL SPORTS

Fitness Training

102

a. **Nike** / Leotards M: Nike Japan b. **Nike** / Tank Tops and Shorts M: Nike Japan c., g. **Reebok** / Leotards M: Reebok Japan
d.-f. **Casio-Exercise Pulse Monitor** / Watches M: Casio h. **Reebok-Inst Graphlite Mid** / Aerobics Shoes M: Reebok Japan
i. **Reebok-Aerostep Reebok Pro** / Aerobics Shoes M: Reebok Japan

103

INDIVIDUAL SPORTS

Fitness Training

104

a. Reebok-The Pump Paydirt / Training Shoes M: Reebok Japan **b. Nike-Air Edge Mid** / Training Shoes M: Nike Japan **c. Reebok-City Jam** / Aerobics Shoes M: Reebok Japan
d. Reebok-Hyperlite Mid / Aerobics Shoes M: Reebok Japan **e. adidas-Torsion XTR1** / Training Shoes LM: Descente **f. Nike-Air Diamond Turf** / Training Shoes M: Nike Japan
g. Nike-Air Trainer Huarache / Training Shoes M: Nike Japan **h. Nike-Air Carnivore** / Training Shoes M: Nike Japan **i. Fila** / Training Shoes LM: Kanebo. Fila Division

105

INDIVIDUAL SPORTS

Golf

106

a.-f. **Benetton Golf** / a., e. Bags, b. Golf Bags, c. Club Carriers, d. Shoe Bags, f. Golf Clubs M: Maruman Golf

107

INDIVIDUAL SPORTS

Golf

108

a. Benetton Golf / Club Covers M: Maruman Golf **b., j. Benetton Golf** / Gloves M: Maruman Golf **c. ellesse** / Jackets 'n' Pants Outfits LM: Goldwin moda
d. Benetton Golf / Polo Shirts M: Benefashion **e. ellesse** / Polo Shirts and Pants LM: Goldwin moda **f., i. ellesse** / Polo Shirts 'n' Pants Outfits LM: Goldwin moda
g. Benetton Golf / Shoes M: Maruman Golf **h. Benetton Golf** / Shirts M: Benefashion

INDIVIDUAL SPORTS

Tennis

110

a., b. **Nobu** / Warm-up Jackets and Pants M: Tennis Factory, The Stereo Studio c., d. **Nobu** / Polo Shirts 'n' Shorts Outfits M: Tennis Factory, The Stereo Studio
e., g., h. **Yonex** / Polo Shirts M: Yonex f. **Yonex** / Polo Shirts and Skirts M: Yonex

111

INDIVIDUAL SPORTS

Tennis

a

b

c

112

a., c. Goldwin / Polo Shirts 'n' Shorts Outfits M: Goldwin **b. Goldwin** / Polo Shirts 'n' Skirts Outfits M: Goldwin **d. Fila** / Polo Shirts LM: Kanebo. Fila Division
e. ellesse / T-shirts 'n' Shorts Outfits LM: Goldwin moda **f. Nike** / Polo Shirts M: Nike Japan **g. Goldwin** / Polo Shirts M: Goldwin

113

INDIVIDUAL SPORTS

Tennis

114

a., b., f., g., h. Wilson Tennis / a., b., g., h. T-shirts, f. Polo Shirts LM: Hit Union c., d., e. Nobu / T-shirts M: Tennis Factory, The Stereo Studio

115

INDIVIDUAL SPORTS

Tennis

116

a., b. Wilson Tennis / T-shirts LM: Hit Union c. Wilson Tennis / Towels LM: Hit Union d. Wilson Tennis / Coats LM: Hit Union

d back

117

INDIVIDUAL SPORTS

Tennis

118

a
b
c
d
e

a. **Yonex-RD 27** / Racquets M: Yonex b. **Wimbledon Junior** / Racquets I: Kunnan International Japan c. **Yamaha-Proto FX110** / Racquets M: Yamaha
d. **Yamaha-EX110 Tour Edition** / Racquets M: Yamaha e. **Yonex-RD 8** / Racquets M: Yonex f. **Wimbledon Stabilizer Jr** / Racquets I: Kunnan International Japan
g. **Wimbledon Stabilizer TV 25** / Racquets I: Kunnan International Japan h. **Wimbledon Inés Elegance** / Racquets I: Kunnan International Japan
i. **Yonex-RA 1000** / Racquets M: Yonex j. **Yonex-RD 22** / Racquets M: Yonex

INDIVIDUAL SPORTS

Tennis

120

a

b

c

d

e

f

a., d. Wimbledon Stabilizer CH23 Ⅱ / Racquets I: Kunnan International Japan **b., c. Prince-Synergy Tour DB** / Racquets I: Daiwa Seiko
e. Prince-Graphite Tour / Racquets I: Daiwa Seiko **f. Prince-Graphite Pro CG** / Racquets I: Daiwa Seiko
g. Prince-Synergy Extender / Racquets I: Daiwa Seiko **h. Prince-Synergy Lite** Ⅰ / Racquets I: Daiwa Seiko **i. Prince-Vortex SB** / Racquets I: Daiwa Seiko
j. Prince-Vortex / Racquets I: Daiwa Seiko **k. Yamaha-EOS·Gold Super Size** / Racquets M: Yamaha **l. Wimbledon Mini** / Racquets I: Kunnan International Japan

121

INDIVIDUAL SPORTS

Tennis

122

a. **Puma-Disc System Response** / Shoes I: Cosa Liebermann b. **adidas-Equipment Tennis Boots** / Shoes LM: Descente c. **adidas-Torsion Edverg Plus** / Shoes LM: Descente
d. **Yonex-Tennis Shoes 150** / Shoes M: Yonex e. **Nike-Air Challenge Future** / Shoes M: Nike Japan f. **Reebok-The Pump Upset Mid** / Shoes M: Reebok Japan
g. **Prince** / Shoes I: Daiwa Seiko h. **Asics-Gelvincitore MT** / Shoes M: Asics i. **Yamaha** / Shoes M: Yamaha

123

INDIVIDUAL SPORTS

Tennis

MODA NELLA VITA SPORTIVA
FILA opera nel mondo dello sport in cinque aree fondamentali: tennis, montagna, fitness, mare e golf.

124

a., b. **Yamaha** / Bags M: Yamaha c.-e., h.-j. **Fila** / Bags LM: Kanebo. Fila Division f., g. **Nobu** / Bags M: Tennis Factory, The Stereo Studio

125

INDIVIDUAL SPORTS

Tennis

a.–e. Wimbledon / Bags I: Kunnan International Japan

INDIVIDUAL SPORTS

126

WATER SPORTS

Swimming 128

Surfing 146

Swimming

128

a., b. ellesse / Swimsuits LM: Goldwin moda c., d. Arena / Swimsuits M: Descente

129

WATER SPORTS

Swimming

130

a

b

c

d

a.-d. **Arena** / Swimsuits M: Descente **e., f. Speed** / Swimsuits M: Mizuno

131

WATER SPORTS

Swimming

132

a.-f. ellesse / Swimsuits LM: Goldwin moda

133

WATER SPORTS

Swimming

134

a

b

c

c

d

a., b., e., f. **arena** / Swimsuits M: Descente c., d., g. **ellesse** / Swimsuits LM: Goldwin moda

135

e

f

d

g

g

WATER SPORTS

Swimming

136

a.-g., j.-m. Como Diana / Swimsuits M: Asics h., i., n., o. Move Point / Swimsuits M: Asics

137

WATER SPORTS

Swimming

138

a

b

c

a.-c. **Senofich** / Swimsuits M: Descente **d., e. Fila** / Swimsuits LM: Kanebo, Fila Division

139

WATER SPORTS

Swimming

140

a

b

c

d

e

a., b., d., e., h. ellesse / Swimsuits LM: Goldwin moda c., g., i. courrèges / Swimsuits LM: Descente f. Speed / Swimsuits M: Mizuno

WATER SPORTS

Swimming

a

back

b

back

c

back

142

a.-e. **Speed** / Swim Pants M: Mizuno **f.-h. Arena** / Swim Pants M: Descente

d

e

143

f back

g

h

WATER SPORTS

Swimming

144

a., b., d., g., h. Speed / Swim Caps M: Mizuno **c., e., f. Arena** / Swim Caps M: Descente **i., j. Arena** / Bags M: Descente **k. adidas-Adilight Kid** / Sandals LM: Descente
l. adidas-Adiletta / Sandals LM: Descente **m., p. adidas-Adilight** / Sandals LM: Descente **n. adidas-Equipment Adiletta** / Sandals LM: Descente **o. Speed** / Sandals M: Mizuno

145

WATER SPORTS

Surfing

146

a.-h. Peakaboo / T-shirts M: Basil

147

WATER SPORTS

Surfing

148

a. **Peakaboo** / Swimsuits M: Basil b. **Peakaboo** / Tappa(Wet Suit Tops) and Vest(Wet Suit Sleeveless Tops) M: Basil c. **Peakaboo** / Jackets M: Basil
d. **Peakaboo** / Wet Suits, Tappa and Swim Pants M: Basil

149

SPORTS

Surfing

DOWN

SURF RAGS

TROPO

ZONK!
FUR·D·BEACH

a

b

c

d

a. California Blues / T-shirts M: California Blues **b., c., f., g. Tropo** / T-shirts M: Tropo **d., e. Zonk** / T-shirts M: Zonk

e

f

g

151

WATER SPORTS

Surfing

152

a., b. O'Neill / T-shirts l: Gum Gum c. Lightning Bolt / Tank Tops l: Gum Gum

WATER SPORTS

Skiing 154

Snowboarding 190

SNOW SPORTS

Skiing

154

a.-c. K2 / Skis M: K2

155

SNOW SPORTS

Skiing

a. **Kastle-TCX 01** / Skis M: Nordica Japan b. **Kastle-TCX 02** / Skis M: Nordica Japan c. **Kastle-Mogul 03** / Skis M: Nordica Japan d. **Kastle-Demo 01** / Skis M: Nordica Japan
e. **Kastle-TCX 05** / Skis M: Nordica Japan

157

SNOW SPORTS

Skiing

d

e

f

a. Kastle-Speed Machine / Skis M: Nordica Japan b. Kastle-Anita / Skis M: Nordica Japan c. Kastle-Demo 03 / Skis M: Nordica Japan d. Atomic-Snowmaster / Skis M: Asics
e. Atomic-Easysteer / Skis M: Asics f. Atomic-Team Demo / Skis M: Asics

159

SNOW SPORTS

Skiing

160

a., b. Blizzard-Wizard III / Skis M: Dunlop Sports c. Blizzard-Thermo VCS / Skis M: Dunlop Sports d. Blizzard-Thermo VCS Lady / Skis M: Dunlop Sports
e. Moguls-FS Mode for Moguls / Skis M: Mizuno f. Moguls-FS Mode for Hyper / Skis M: Mizuno g. Racing-DH Mode / Skis M: Mizuno h. Racing-SG Mode / Skis M: Mizuno

161

SNOW SPORTS

Skiing

162

a

b

c

a. **Rossignol-EM 1** / Skis M: Rossignol Japan b. **Rossignol-Souplesse 2** / Skis M: Rossignol Japan c. **Rossignol-EM Super** / Skis M: Rossignol Japan
d. **Rossignol-Serrata** / Skis M: Rossignol Japan e., f. **Rossignol-Arpege** / Skis M: Rossignol Japan

163

SNOW SPORTS

Skiing

164

a.-c., e.-h. **K2** / Skis M: K2 d. **K2-Rage** / Skis M: K2

165

SNOW SPORTS

Skiing

a

b

b

c

d

166

e

f

a. **Rossignol-Vintage** / Skis M: Rossignol Japan b. **Rossignol-Solaris** / Skis M: Rossignol Japan c. **Rossignol-Solo** / Skis M: Rossignol Japan
d. **Atomic-Demo Lady Carbon** / Skis M: Asics e. **Atomic-Extreme Ceramic** / Skis M: Asics f. **Atomic-Demo Ceramic** / Skis M: Asics

167

SNOW SPORTS

Skiing

a

b

b

c

d

e

a. **Elan-SC Sports** / Skis LM: Dai-ichi Shoji b. **Elan-MBX Demo, Expert** / Skis M: Elan Ski d.o.o. c. **Blizzard-Racer** / Skis M: Dunlop Sports
d. **Atomic-Super Demo Lady** / Skis M: Asics e. **Atomic-Demo Lady Kevlar** / Skis M: Asics f. **Teddy Bear** / Skis M: Mizuno

169

SNOW SPORTS

Skiing

170

a

b

c

d

e

a. **Rossignol-Solaris** / Ski Poles M: Rossignol Japan b. **Rossignol-Super Virage** / Ski Poles M: Rossignol Japan c. **Rossignol-Virage Lady** / Ski Poles M: Rossignol Japan
d. **Rossignol-High Performance** I / Ski Poles M: Rossignol Japan e. **Rossignol-Serrata** / Ski Poles M: Rossignol Japan f. **Atomic-Demo Lady Kevlar** / Ski Poles M: Asics
g. **Atomic-Demo Lady Ceramic** / Ski Poles M: Asics h. **Atomic-Demo Carbon** / Ski Poles M: Asics i. **Atomic-Super Demo** / Ski Poles M: Asics
j. **Atomic-ARC Racing** / Ski Poles M: Asics

171

SNOW SPORTS

Skiing

172

a

b

c

d

e

a., b., f., g. **Atomic** / Gloves M: Asics c. **Atomic-Carbon** / Ski Poles M: Asics d., e., h. **Atomic-ARC Racing** / Ski Poles M: Asics
i. **Team Daiwa-Carboflex** / Ski Poles M: Daiwa Seiko

173

SNOW SPORTS

Skiing

174

a. **Nordica-TR 9** / Boots M: Nordica Japan b. **Nordica-Vertech 85** / Boots M: Nordica Japan c. **Nordica-AFX 80** / Boots M: Nordica Japan
d. **Nordica-NX 9.5** / Boots M: Nordica Japan e., f. **Nordica-GP** / Boots M: Nordica Japan

175

SNOW SPORTS

Skiing

176

a

b

c

d

a. **Rossignol-Demo Ⅱ** / Boots M: Rossignol Japan b. **Rossignol-Mid M9 Plus** / Boots M: Rossignol Japan c. **Rossignol-R97 Lady** / Boots M: Rossignol Japan
d. **Rossignol-Course Kevlar** / Boots M: Rossignol Japan e. **Daiwa Hanson-tc 9** / Boots I: Daiwa Seiko f. **Daiwa Hanson-F 75** / Boots I: Daiwa Seiko
g. **Mizuno-92 Mode 7** / Boots M: Mizuno h. **Rossignol-Mid M3 Plus** / Boots M: Rossignol Japan

Skiing

178

a. Daiwa Hanson / Gloves I: Daiwa Seiko **b., h., i. Oline Skis** / Gloves I: Daiwa Seiko **c. Rossignol-Top Demo** / Goggles M: Rossignol Japan
d. Mizuno-Mode / Goggles M: Mizuno **e. Rossignol-DH Racing** / Helmets M: Rossignol Japan **f. Rossignol-Lady Mode R** / Goggles M: Rossignol Japan
g. Rossignol-EM Super / Goggles M: Rossignol Japan

179

SNOW SPORTS

Skiing

180

a. Phenix-Team FIS / Jackets M: Phenix **b., c. Phenix-Mountain** / Jackets M: Phenix **d. Phenix-Expert** / Jackets M: Phenix **e. Phenix-Technical** / Jackets M: Phenix
f. Ficce Sports / Jackets LM: Goldwin moda

181

SNOW SPORTS

Skiing

182

a.-i. Phenix-Norway Alpine Ski Team (World Cup Model) / a. Jackets, b.-d., f., h. Hats, e. Head Bands, g. Gloves, i. Shirts M: Phenix
j.-o. Phenix-Norway Alpine Ski Team (World Championship Model) / j. Jackets, k., m. Hats, l. Gloves, n. Leggings, o. Head Bands M: Phenix

j back

183

SNOW SPORTS

Skiing

184

a.-j. Phenix-Mountain / a., b., i. Bags, c. Jackets, d. Caps, e. Gloves, f. Socks, g. Shirts, h. Head Bands, j. Ski Covers M: Phenix

k.-s. Phenix-Expert / k. Jackets, l. Shirts, m., p. Hats, n., r., s. Bags, o. Gloves, q. Head Bands M: Phenix

185

SNOW SPORTS

Skiing

186

a.-g. Bogner / a. Sweater and Leggings, b. Bags, c. Jackets and Pants, d. Speed Suits, e. Gloves, f., g. Hats M: Bogner LM: Phenix

187

Skiing

188

a.–h. Atomic / a., h. Hats, b., g. Jackets, c.–f. Gloves M: Asics

189

e

f

g

h h h

SNOW SPORTS

Snowboarding

190

a., b., c., e. **Heavy Tools-Trash Line (a. Lomgbone, b. Trickbone, c. Midbone, e. Classic)** / Snowboards I: Jykk Japan d. **Heavy Tools-Tattoo Line** / Snowboards I: Jykk Japan
f. **Heavy Tools-Alpine Boards (Lizard)** / Snowboards I: Jykk Japan g. **K2** / Snowboards M: K2

191

d base

SNOW SPORTS

Snowboarding

192

a

a base

b

b base

c base

c

a., b., d. **Heavy Tools-Design-boards (a. Chainsaw, b. Joystick, d. Killer Sperm)** / Snowboards I: Jykk Japan c., f. **Nitro-Scrambler** / Snowboards I: PIAA
e. **Heavy Tools-New School (Bulldog)** / Snowboards I: Jykk Japan

193

SNOW SPORTS

Snowboarding

194

a

b

c

d

e

a. Nitro-Sting 166 / Snowboards I: PIAA **b. Nitro-Fury** / Snowboards I: PIAA **c., d. Rook-Pure Line** / Snowboards I: Jykk Japan **e.–i. K2** / Snowboards M: K2

195

SNOW SPORTS

Snowboarding

196

a. Nitro-Powder Gun / Snowboards I: PIAA **b. Nitro-Tour** / Snowboards I: PIAA **c. Nitro-Scorpion** / Snowboards I: PIAA **d. Nitro-Range** / Snowboards I: PIAA
e. Nitro-Flux / Snowboards I: PIAA **f. Nitro-Spark** / Snowboards I: PIAA **g. Nitro-Hazard** / Snowboards I: PIAA

197

SNOW SPORTS

Snowboarding

198

a.-c., j., k. O'Neill / Hats l: Gum Gum **d., e., l. O'Neill** / Gloves l: Gum Gum **f. Cocoon-Lotus** / Snowboards l: Minami **g. Cocoon-Aton** / Snowboards l: Minami
h. Cocoon-Tuareg / Snowboards l: Minami **i. Cocoon-'48** / Snowboards l: Minami

199

SNOW SPORTS

Snowboarding

200

a

b

c

d

e

f

a.-f. **Nitro** / T-shirts l: PIAA g., h., n., o. **K2** / T-shirts M: **K2** i.-m. **K2** / Caps M: **K2**

201

SNOW SPORTS

Snowboarding

202

a.-e., g., h. O'Neill / a., b., d., e., g., h. Jackets, c. Coats I: Gum Gum **f. Ocean Duck** / Jackets and Pants I: PIAA

203

SNOW SPORTS

Snowboarding

204

SNOW SPORTS

a.-d. O'Neill / Bags 1: Gum Gum

SPORTS FASHION

Sports Fashion 206

Sports Fashion

206

a. **ellesse** / Parka 'n' Shorts Outfits LM: Goldwin moda b.-e. **Wilson** / b. Shirts 'n' Pants Outfits, c.-e. Shirts 'n' Shorts Outfits LM: Hit Union

SPORTS FASHION

Sports Fashion

208

a., b., e. Wilson / Shirts LM: Hit Union c., d., f. Puma All Sports / Shirts LM: Hit Union

209

SPORTS FASHION

Sports Fashion

210

a.-g., i-k. Fila / a.-g. T-shirts i-k. T-shirts 'n' Shorts Outfits LM: Kanebo. Fila Division h., l. Wilson / T-shirts LM: Hit Union

211

SPORTS FASHION

Sports Fashion

212

a., c. Wilson / a. T-shirts 'n' Shorts Outfits, c. T-shirts LM: Hit Union **b. Fila** / T-shirts 'n' Shorts Outfits LM: Kanebo. Fila Division
d. adidas-Standard / Bags LM: Descente **e. Mizuno-Run Bird** / Bags M: Mizuno **f. Asics** / Bags M: Asics

SPORTS FASHION

Sports Fashion

214

a.-j. adidas / T-shirts LM: Descente

215

SPORTS FASHION

Sports Fashion

216

a.–c. **adidas** / a., c. T-shirts 'n' Shorts Outfits b. Shirts LM: Descente

SUBMITTORS' INDEX

Submittors' Index

Asics Corporation
22, 23, 54, 55, 57, 98, 99, 123, 136, 137, 158, 159, 166, 167, 168, 169, 170, 171, 172, 173, 188, 189, 213

Basil Corporation
146, 147, 148, 149

Casio Computer Co., Ltd.
102

Cosa Liebermann K. K.
30, 32, 33, 35, 57, 100, 122

D-2 Incorporated
168, 169

Daiwa Seiko Inc.
88, 89, 120, 121, 123, 173, 177, 178, 179

Descente, Ltd.
31, 32, 33, 34, 35, 56, 59, 94, 101, 105, 122, 129, 130, 134, 135, 138, 140, 141, 143, 144, 145, 213, 214, 215, 216

Dunlop Sports Ltd.
160, 161, 168, 169

Goldwin moda
108, 109, 112, 113, 128, 129, 132, 133, 134, 135, 140, 141, 181, 206

Gum Gum Inc.
152, 198, 199, 202, 203, 204

Hit Union Co., Ltd.
21, 42, 43, 95, 114, 115, 116, 117, 206, 207, 208, 209, 210, 211, 212

Hornall Anderson Design Works
88, 89, 154, 155, 164, 165

Japan Sports Vision Co., Ltd.-MLB Japan Shop
62, 63, 64, 65, 66, 67, 68, 69, 70, 71

Japan Sports Vision Co., Ltd.-World Sports Plaza
72, 73, 74, 75, 76, 77, 78, 79, 80, 81, 82, 84

**Japan Sports Vision Co., Ltd.
-World Sports Plaza Campione**
10, 11, 12, 13, 14, 15, 16, 17, 18, 19, 20, 21

Japan Sports Vision Co., Ltd.-World Sports Plaza 2
36, 37, 38, 39, 40, 41, 46, 47, 48, 49, 50, 51, 60, 61

Jykk Japan Inc.
190, 191, 192, 193, 194

Kanebo Ltd. Fila Division
57, 105, 113, 124, 125, 139, 210, 211, 212

Kunnan International Japan Ltd.
118, 119, 120, 121, 126

Minami Corporation
198, 199

Mizuno Corporation
24, 25, 26, 27, 28, 29, 70, 71, 95, 99, 131, 141, 142, 143, 144, 145, 160, 161, 168, 169, 177, 178, 213

Modern Dog
43, 68, 164, 165, 191, 194, 195, 201

Nike Japan
44, 45, 58, 96, 97, 102, 104, 105, 113, 123

Nordica Japan Co., Ltd.
92, 93, 156, 157, 158, 159, 174, 175

Pearl Izumi, Inc.
84, 85, 86, 87, 90, 91

Phenix Co., Ltd.
180, 181, 182, 183, 184, 185, 186, 187

PIAA Corporation
192, 193, 194, 196, 197, 200, 203

Reebok Japan
48, 49, 54, 55, 96, 97, 102, 103, 104, 123

Rossignol Japan
162, 163, 166, 167, 170, 176, 177, 178, 179

Sabin Design-Tracy Sabin
150, 151

Stereo Studio Inc., The
110, 114, 125

Tachikara Co., Ltd.
52, 53

Tennis Factory Inc.
110, 114, 125

United Agency K. K.
106, 107, 108, 109

Yamaha Corporation
118, 121, 123, 124

Yonex Co., Ltd.
111, 118, 119, 122

SPORTS GRAPHICS

Art Directors
Kazuo Abe / Shinji Ikenoue

Designers
Shinji Ikenoue / Miyuki Kawanabe

Editors
Ayako Aoyama / Kaoru Endo

Business Manager
Masato Ieshiro

Photographer
Kuniharu Fujimoto

Coordinator
Chizuko Gilmore (San Francisco)

English Translator & Adviser
Sue Herbert

Publisher
Shingo Miyoshi

Special Thanks to:
MLB Japan Shop, Tokyo (TEL: 03-3462-7711)
World Sports Plaza, Tokyo (TEL: 03-3462-1001)
World Sports Plaza Campione, Tokyo (TEL: 03-3407-6240)
World Sports Plaza 2, Tokyo (TEL: 03-5466-1501)
Naomi Sakuma / Noriko Yamada

1994年11月10日初版第1版発行

発行所 ピエ・ブックス
〒170 東京都豊島区駒込4-14-6 ビラフェニックス301
TEL: 03-3949-5010 FAX: 03-3949-5650

製版・印刷・製本 エバーベスト・プリンティング㈱
Printed by **Everbest Printing Co., Ltd.** (Hong Kong)

©1994 **P·I·E BOOKS**

本書の収録内容の無断転載ならびに複写、引用等を禁じます。
乱丁・落丁はお取り替えいたします。

ISBN4-938586-53-3 C3070 P16000E

P·I·E Books, as always, has several new and ambitious graphic book projects in the works which will introduce a variety of superior designs from Japan and abroad. Currently we are planning the collection series detailed below. If you have any graphics which you consider worthy for submission to these publications, please fill in the necessary information on the inserted questionnaire postcard and forward it to us. You will receive a notice when the relevant project goes into production.

REQUEST FOR SUBMISSIONS

- **A.** Postcard Graphics
- **B.** Advertising Greeting Cards
- **C.** Brochure & Pamphlet Collection
- **D.** Poster Graphics
- **E.** Book Cover and Editorial Design
- **F.** Corporate Image Design
- **G.** Business Card and Letterhead Graphics
- **H.** Calendar Graphics
- **I.** Packaging and Wrapping Graphics

ピエ・ブックスでは、今後も新しいタイプのグラフィック書籍の出版を目指すとともに、国内外の優れたデザインを幅広く紹介していきたいと考えております。今後の刊行予定として下記のコレクション・シリーズを企画しておりますので、作品提供していただける企画がございましたら、挟み込みのアンケートハガキに必要事項をご記入の上お送り下さい。企画が近づきましたらそのつど案内書をお送りいたします。

作 品 提 供 の お 願 い

- **A.** ポストカード・グラフィックス
- **B.** アドバタイジング・グリーティングカード
- **C.** ブローシュア & パンフレット・コレクション
- **D.** ポスター・グラフィックス
- **E.** ブックカバー&エディトリアル・デザイン
- **F.** コーポレイト・イメージ & ロゴマーク・デザイン
- **G.** ビジネスカード&レターヘッド・グラフィックス
- **H.** カレンダー・グラフィックス
- **I.** パッケージ&ラッピング・グラフィックス

Comme toujours, P·I·E Books a dans ses ateliers plusieurs projets de livres graphiques neufs et ambitieux qui introduiront une gamme de modèles supérieurs en provenance du Japon et de l'étranger. Nous prévoyons en ce moment la série de collections détaillée cidessous. Si vous êtes en possession d'un graphique que vous jugez digne de soumettre à ces publications, nous vous prions de remplir les informations nécessaires sur l'étiquette à renvoyer située à la carte postale questionnaire insérée et de nous la faire parvenir. Vous recevrez un avis lorsque le projet correspondant passera à la production.

DEMANDE DE SOUMISSIONS

- **A.** Graphiques pour cartes postales
- **B.** Cartes de voeux publicitaires
- **C.** Collection de brochures et de pamphlets
- **D.** Graphiques sur affiche
- **E.** Designs de couverture de livre et d'éditorial
- **F.** Designs de logo d'image de société
- **G.** Graphiques pour en-têtes et cartes de visite
- **H.** Graphiques pour calendrier
- **I.** Graphiques pour emballage et paquetage

Wie immer hat P·I·E Books einige neue anspruchsvolle Grafikbücher in Arbeit, die eine Vielzahl von hervorragenden Designs aus Japan und anderen Ländern vorstellen werden. Momentan planen wir eine Serie mit den nachfolgend aufgeführten Themen. Wenn Sie grafische Darstellungen besitzen, von denen Sie meinen, daß sie in diese Veröffentlichung aufgenommen werden könnten, geben Sie uns bitte die nötigen Informationen auf der entsprechenden Antwortseite und füllen Sie die beigelegte Antwortkarte aus, und schicken Sie sie an uns. Wir werden Sie benachrichtigen, wenn das entsprechende Projekt in Arbeit geht.

AUFFORDERUNG ZU MITARBEIT

- **A.** Postkarten-Grafik
- **B.** Werbe-Grußkarten
- **C.** Zusammenstellung von Broschüren und Druckschriften
- **D.** Postergrafik
- **E.** Bucheinbände und redaktionelles Design
- **F.** Corporate-Image-Logo-Design
- **G.** Visitenkarten und Briefkopf-Grafik
- **H.** Kalendergrafik
- **I.** Grafik auf Verpackungen und Verpackungsmaterial

THE P·I·E COLLECTION

BROCHURE & PAMPHLET COLLECTION 1
Pages: 224(144 in color) ¥15,000
業種別カタログ・コレクション
Here are hundreds of the best brochures and pamphlets from Japan.
This collection will make a valuable sourcebook for anyone involved in corporate identity advertising and graphic design.

LABELS AND TAGS
Pages: 224(192 in color) ¥15,000
ファッションのラベル＆タグ・コレクション
Over 1,600 garment labels representing 450 brands produced in Japan are included in this full-color collection.

COVER TO COVER
Pages: 240(176 in color) ¥17,000
世界のブック＆エディトリアル・デザイン
The latest trends in book and magazine design are illustrated with over 1,000 creative works by international firms.

BUSINESS STATIONERY GRAPHICS 1
Pages: 224(192 in color) ¥15,000
世界のレターヘッド・コレクション
Creatively designed letterheads, business cards, memo pads, and other business forms and documents are included this international collection.

CORPORATE IMAGE DESIGN
Pages: 336(272 in color) ¥16,000
世界の業種別ＣＩ・ロゴマーク
This collection presents the best corporate identity projects from around the world. Creative and effective designs from top international firms are featured in this valuable source book.

POSTCARD GRAPHICS 3
Pages: 232(208 in color) ¥16,000
世界の業種別ポストカード・コレクション
Volume 3 in the series presents more than 1,200 promotional postcards in dazzling full color. Top designers from the world over have contributed to this useful image bank of ideas.

GRAPHIC BEAT London / Tokyo 1 & 2
Pages: 224(208 in color) ¥16,000
音楽とグラフィックのコラボレーション
1,500 music-related graphic works from 29 of the hottest designers in Tokyo and London. Features Malcolm Garrett, Russell Miles, Tadanori Yokoo, Neville Brody, Vaughn Oliver and others.

BUSINESS CARD GRAPHICS 2
Pages: 224(192 in color) ¥16,000
世界の名刺＆ショップカード、第2弾
This latest collection presents 1,000 creative cards from international designers. Features hundreds of cards used in creative fields such as graphic design and architecture.

T-SHIRT GRAPHICS
Pages: 224(192 in color) ¥16,000
世界のＴシャツ・グラフィックス
This unique collection showcases 700 wonderfully creative T-Shirt designs from the world's premier design centers. Grouped according to theme, categories include sports, casual, designer and promotional shirts among others.

DIAGRAM GRAPHICS
Pages: 224(192 in color) ¥16,000
世界のダイアグラム・デザインの集大成
Hundreds of unique and lucid diagrams, charts, graphs, maps and technical illustrations from leading international design firms. Variety of media represented including computer graphics.

SPECIAL EVENT GRAPHICS
Pages: 224(192 in color) ¥16,000
世界のイベント・グラフィックス特集
This innovative collection features design elements from concerts, festivals, fashion shows, symposiums and more. International works include posters, tickets, flyers, invitations and various premiers.

RETAIL IDENTITY GRAPHICS
Pages: 208(176 in color) ¥14,800
世界のショップ・グラフィックス
This visually exciting collection showcases the identity design campaigns of restaurants, bars, shops and various other retailers. Wide variety of pieces are featured including business cards, signs, menus, bags and hundreds more.

THE P·I·E COLLECTION

PACKAGING DESIGN & GRAPHICS 1
Pages: 224(192 in color) ￥16,000
世界の業種別パッケージ・デザイン
An international collection featuring 400 creative and exciting package designs from renowned designers.

ADVERTISING GREETING CARDS 3
Pages: 224(176 in color) ￥16,000
世界のダイレクトメール大成、第3弾
The best-selling series continues with this collection of elegantly designed advertising pieces from a wide variety of categories. This exciting image bank of ideas will interest all graphic designers and direct mail specialists.

NEW TYPO GRAPHICS
Pages: 224(192 in color) ￥16,000
世界の最新タイポグラフィ・コレクション
New and innovative typographical works gathered from top designers around the world. A wide variety of type applications are shown including posters, brochures, CD jackets, calendars, book designs and more.

The Production Index ARTIFILE 2
Pages: 244(240 in color) ￥13,500
活躍中！最新プロダクション年鑑、第2弾
A design showcase featuring the best works from 115 graphic design studios, photographers, and creators in Japan. Works shown include print advertisements, corporate identity pieces, commercial photography and illustration.

CREATIVE FLYER GRAPHICS
Pages: 224(176 in color) ￥16,000
チラシ・グラフィックス
Features about 500 rigorously screened flyers and leaflets. You see what superior graphics can accomplish on a single sheet of paper. This is an invaluable reference to all your advertising production for years to come.

1, 2 & 3 COLOR GRAPHICS
Pages: 208(Full Color) ￥16,000
1・2・3色 グラフィックス
See about 300 samples of 1,2 & 3 color artwork that are so expressive they often surpass the impact of full 4 color reproductions. This is a very important book that will expand the possibilities of your design works in the future.

LABELS AND TAGS 2
Pages: 224(192 in color) ￥16,000
世界のラベル＆タグ・コレクション　2
This long-awaited second volume features 1500 samples representing 400 top name-brands from around the world.

BROCHURE DESIGN FORUM 2
Pages: 224(176 in color) ￥16,000
世界の最新カタログ・コレクション　2
Features 70 businesses and 250 reproductions for a complete overview of the latest and best in brochure design.

POSTER GRAPHICS 2
Pages: 256(192 in color) ￥17,000
業種別世界のポスター集大成
700 posters from the top creators in Japan and abroad are showcased in this book - classified by business. This invaluable reference makes it easy to compare design trends among various industries and corporations.

BUSINESS STATIONERY GRAPHICS 2
Pages: 224(192 in color) ￥16,000
世界の業種別レターヘッド・コレクション、第2弾
The second volume in our popular "Business Stationery Graphics" series. This publication focuses on letterheads, envelopes and business cards, all classified by business. This collection will serve artists and business people well.

SENSUAL IMAGES
Pages: 208(98 in color) ￥4,800
世界の官能フォト傑作集
We selected the best sensual works of 100 photographers from all over the world. The result is 200 sensual images concentrated in this volume. Page after page of photos that will quicken your pulse and stimulate your fantasies!

BROCHURE & PAMPHLET COLLECTION 3
Pages: 224(176 in color) ￥16,000
好評！業種別カタログ・コレクション、第3弾
The third volume in "Brochure & Pamphlet" series. Sixteen types of businesses are represented through artwork that really sell. This book conveys a sense of what's happening now in the catalogue design scene. A must for all creators.

THE P·I·E COLLECTION

DIRECT MAIL GRAPHICS 1
Pages: 224(176 in color) ¥16,000
衣・食・住のセールスDM特集！
The long-awaited design collection featuring direct mailers with outstanding sales impact and quality design. 350 of the best pieces, classified into 100 business categories. A veritable textbook of current direct marketing design.

3-D GRAPHICS
Pages: 224(192 in color) ¥16,000
3-D・グラフィックスの大百科
300 works that demonstrate the best possibilities of 3-D graphic methods, including DMs, catalogues, posters, POPs and more. The volume is a virtual encyclopedia of 3-D graphics.

The Production Index ARTIFILE 3
Pages: 224(Full color) ¥13,500
活躍中！最新プロダクション年鑑、第3弾
Contributors are 116 top production companies and artists. See the artwork and read insightful messages from the creators.

ALL OF SSAWS
Pages: 120(Full color) ¥8,800
ザウスのCI、アプリケーション＆グッズ
The graphics of SSAWS - the world's No.1 all-season ski dome is showcased in this publication; everything from CI and rental wear to notions and signs. This is the CI concept of the future - design that changes, evolves and propagates freely.

TYPO-DIRECTION IN JAPAN 5
Pages: 254(183 in color) ¥17,000
年鑑　日本のタイポディレクション'93
314 award-winning typographic works from around the world are shown in this book. It includes recent masterpieces by eminent art directors and designers as well as powerful works by up-and-comoing designers.

T-SHIRT PRINT DESIGN & LOGOS
Pages: 224(192 in color) ¥16,000
世界のTシャツ・プリントデザイン＆ロゴ
Volume 2 of our popular "T-shirt Graphics" series. In this publication, 800 designs for T-shirt graphics, including many trademarks and logotypes are showcased. The world's top fashion makers are featured.

カタログ・新刊のご案内について
総合カタログ、新刊案内をご希望の方は、はさみ込みのアンケートはがきをご返送いただくか、90円切手同封の上、ピエ・ブックス宛お申し込み下さい。

CATALOGUES ET INFORMATIONS SUR LES NOUVELLES PUBLICATIONS
Si vous désirez recevoir un exemplaire gratuit de notre catalogue général ou des détails sur nos nouvelles publications, veuillez compléter la carte réponse incluse et nous la retourner par courrierou par fax.

CATALOGS and INFORMATION ON NEW PUBLICATIONS
If you would like to receive a free copy of our general catalog or details of our new publications, please fill out the enclosed postcard and return it to us by mail or fax.

CATALOGE und INFORMATIONEN ÜBER NEUE TITLE
Wenn Sie unseren Gesamtkatalog oder Detailinformationen über unsere neuen Titel wünschen, fullen Sie bitte die beigefügte Postkarte aus und schicken Sie sie uns per Post oder Fax.

ピエ・ブックス
〒170 東京都豊島区駒込 4-14-6-301
TEL: 03-3949-5010 FAX: 03-3949-5650

P·I·E BOOKS
#301, 4-14-6, Komagome, Toshima-ku, Tokyo 170 JAPAN
TEL: 03-3949-5010 FAX: 03-3949-5650